Digital Photography for Beginners

~

Basic Techniques on How to Make Your Digital Photos Look Amazing

Jane Morgan

Copyright © 2015 Jane Morgan

All rights reserved.

ISBN: 1514349965
ISBN-13: 978-1514349960

CONTENTS

	Book Description	4
	Introduction	5
1	Understanding Your Camera	9
2	Visualizing The Outcome	15
3	Taking The Winning Photograph	19
4	A Little Art, A Little Magic	24
	Conclusion	28

Book Description

You might be an aspiring young photographer hoping to learn the tricks of the trade, or a person who just invested in a fancy new DSLR (Digital Single-Lens Reflex) and can't wait to take some stunning pictures to put on a new Facebook photography page. Maybe you're just curious and don't want to look like an idiot the next time someone hands you their camera and asks you to take their picture. In all these cases, you're probably looking for the answer to the age-old question photographers get asked: "How do I take better pictures?" Well, this book will teach you how.

What you'll learn in this Book:

- The meaning of technical terms like shutter speed and aperture and how they affect your picture quality.

- How to shoot different scenes and how to use light and the background to your advantage.

- How to ensure that your picture resembles the idea you had in your mind as much as possible.

Plus a lot more useful tips! A good photographer doesn't need a fancy camera to take a good picture, just the right knowledge. Photography is considered an art, but equipped with a camera and this complete guidebook to photography, you will almost never go wrong when trying to capture a moment. All you need is the passion, dedication and creativity to be able to commit yourself to learning this skill, and with a little bit of hard work and polishing up, you'll be shooting like a pro!

Introduction

First and foremost I want to thank you for purchasing this book.

With the introduction of social media, the popularity of digital photography has increased exponentially. Parties, birthdays, weddings--every occasion--have to be covered by a photographer and the photos shared with the world. Thus, it is all the more important that these pictures come out perfect as we immortalize moments in time.

First and foremost it is important to get acquainted with all the technicalities involved while taking a picture. It may seem like a boring, lengthy task, but once you get the hang of it, your pictures will turn out amazing. It's all about learning how to use different scenarios and tweak settings here and there to enhance picture quality and give that extra edge that sets your photographs apart from those of other novice photographers.

Alongside perfecting one's technique, there are a few other points to keep in mind that drastically improve one's photography skills. These include always ensuring that your camera lens is clean and your batteries are charged. It may sound obvious but a lot of times we forget these points. Furthermore, the only sure way to improve on your skills is to practice, practice and practice some more!

Take your camera everywhere with you and take as many pictures as you can. In fact, take multiple pictures of the same scene and then see how you can improve on each one by making adjustments here and there. You can change angles or camera

settings. Last, but not the least, don't be afraid to share your photos and learn to take constructive criticism so you can improve! Good pictures come from intelligent photographers who know how to make the most of what they have and think outside the box, whether it's a phone camera or a professional DSLR.

Copyright © 2015 - Jane Morgan

All rights reserved. No part of this book may be reproduced in any form without permission in writing from the author. Reviewers may quote brief passages in reviews.

Disclaimer

No part of this publication may be reproduced or transmitted in any form or by any means, mechanical or electronic, including photocopying or recording, or by any information storage and retrieval system, or transmitted by email without permission in writing from the publisher.

While all attempts and efforts have been made to verify the information held within this publication, neither the author nor the publisher assumes any responsibility for errors, omissions, or opposing interpretations of the content herein.

This book is for entertainment purposes only. The views expressed are those of the author alone, and should not be taken as expert instruction or commands. The reader of this book is responsible for his or her own actions when it comes to reading the book.

Adherence to all applicable laws and regulations, including international, federal, state, and local governing professional licensing, business practices, advertising, and all other aspects of doing business in the US, Canada, or any other jurisdiction is the sole responsibility of the purchaser or reader.

Neither the author nor the publisher assumes any

responsibility or liability whatsoever on the behalf of the purchaser or reader of these materials.

Any received slight of any individual or organization is purely unintentional.

CHAPTER 1

Understanding Your Camera

The first thing to do before starting any photography project is get to know your camera inside and out. Take out the camera manual and take your time reading it; understand every function that your camera has. Fiddle with the different settings and buttons; learn what each one does. You should be able to grasp how your camera works and all that it is capable of *before* using it. This is especially recommended if you have SLR (Single-Lens Reflex) or DSLR cameras.

Once you have read through the thick manuals, you will definitely appreciate all that these cameras can do for you. Having a basic idea of your camera will help you understand how different techniques can be applied to your benefit. To be able to use the different camera settings explained below you have to learn how to apply them on *your* camera first!

The first thing to do is educate yourself as to the meaning of basic photography terms and techniques and how they affect picture quality. Obviously, it is impossible to learn all these technical terms immediately, so take it slowly, and try to integrate these techniques into your pictures. After a while it will become natural as the concept in your mind becomes clearer, and you'll be able to develop an instinct as to how each setting should be altered in different scenarios.

Camera Resolution

The resolution of your camera is basically its ability to capture details when you take a picture. Thus, higher camera resolution means that your camera is capable of capturing more details. This means these pictures will not only be of better quality but also, the higher the camera resolution, the more you can enlarge a photograph without its becoming grainy and blurry. Whatever camera you have, make sure it is set to a high resolution mode. It is important to keep in mind that taking pictures in high resolution also means that this will take up more memory in your camera, so always have extra memory cards handy in case you run out of storage. If you want to capture special moments, please don't ruin the memories by taking low resolution pictures!

ISO Settings

ISO (International Standards Organization) is a standardized scale used to measure the sensitivity of light.

ISO settings can be a little tricky to maneuver. In simple words, ISO indicates how sensitive your camera is to light. The higher this sensitivity, the easier it is for the camera to capture a picture in low light settings. This also means that the camera can take much less time to take an image, and a camera that is not as sensitive needs more time to capture the same image.

This is why cameras with high ISOs are so much more expensive. But does this mean you should always have your

camera set to the highest ISO setting possible? Not exactly. The problem with high ISO settings is that they make a picture more "grainy." Take two pictures of the same object with only the ISO settings changed. Notice the difference? This "grainy" appearance of the photos is called "digital noise" and every photographer makes an effort to remove it from their photographs. To be able to do this, all you have to do is adjust your ISO settings according to the lighting already available to you.

If you are in an environment with a lot of natural light already, then it's best to keep your ISO settings as low as possible. However, this means the pictures will take longer to capture, so this is not advisable when trying to capture moving objects. They'll be blurry! In situations with low light or if you're trying to capture a moving object, switch to higher ISO settings. Basically, it's just a game of learning how to balance the speed at which the picture is taken with the amount of "noise" in the picture and one can only get the hang of it with practice!

Aperture Settings

Aperture settings can be difficult to understand, but it is especially important to understand how this feature works along with the ISO settings and camera focus. Aperture settings control how much light is allowed into the camera. These settings are denoted by f/ (a certain number). For example f/4 will mean a wide aperture, whereas f/22 for instance means a narrow aperture.

But what exactly does a wide or narrow aperture mean?

Well, when you have a wide aperture, this focuses in on the subject that you are shooting and sort of blurs out the background. So this is a very useful setting when trying to draw attention away from the background and focus on the subject itself. Narrow aperture settings do the exact opposite. With a narrow aperture the background is also included in the image and isn't blurry.

Narrow aperture setting is good when shooting landscapes because it ensures that the maximum amount of details that can be captured are included in the picture. This is true whether the detail is in the background or right in front of the camera. As a beginner it is best to set your aperture settings to about two points above the minimum settings that your camera has to offer. Once you get the hang out of it, don't forget to continue to play around with these settings!

Shutter Speed

We learned that your aperture settings control the light allowed into the camera. Well your shutter speed controls how long your camera is exposed to that light. With a high shutter speed, you can take quicker photos of moving objects. This helps to freeze motion in the image captured. On low shutter speeds, there is much more exposure and thus it takes more time to produce the image, but this helps blur out the image if that is the effect that you are looking for. Again, it is advisable that you take different photos of a moving object with various shutter speeds to see for yourself how speed affects your image.

White Balance

In our everyday life, our brains always help compensate for how we see and interpret colors. For example, on an extremely sunny day, you don't see everything with a yellow tinge. That is because your brain compensates and understands that this is normal. Unfortunately, our cameras aren't as powerful a machine as our brains. They can't automatically figure out how pictures should look in different lighting which is why these settings have to be adjusted. Luckily, most cameras have built-in settings which means that we don't have to manually change these settings except in certain situations. For example, if you are shooting on a cloudy day, set the settings in your camera to "cloudy" and the camera will adjust itself automatically.

As a general rule, direct sunlight makes the image look bluish; incandescent lights have a warmer effect on the picture than daylight. Fluorescent light can result in things looking green.

The absolutely best time to take photos is either at sunrise or sunset. These times are known as the "golden" hours of photography as the light is soft and beautiful at this time and the pictures come out amazing. This golden hour light makes everything have a soft reddish or yellowish sort of glow.

Auto Focus Settings

Every digital camera has a vast array of modes that help focus the camera. Most cameras allow you to select what auto focus points (AF POINTS) you want and where you want to focus. AF means

that the camera will do the focusing for you. In other words the camera will try to take the very best shot for you. Many experienced photographers will typically not use the AF setting since the camera doesn't know what you really want to shoot. It may be accurate at times but other times not so much. So it is best to manually adjust these settings. If for example, your subject is moving, then the camera can also be set to a mode called the "continuous AF mode" which functions by maintaining focus on whatever the subject is even though it is moving. For stationary subjects, however, a single AF point is not only reliable but also extremely quick.

Now that you have a basic idea of camera settings and how to apply them, you can move on to actually learn how to take an amazing picture. This is where your creativity comes in and you can try different techniques to bring about the result that you like best.

CHAPTER 2

Visualizing the Outcome

The first thing to do before actually taking the picture is to think about what you want in your picture. What sort of effect are you trying to achieve? What is the focus of your image? Taking a few minutes before capturing the image can make the outcome five times better. It is not just the camera's job to take a beautiful picture; it is your job as the artist to take a picture of the world in the way that you see it. First, when you look through the camera lens, try to take in as much detail as possible. Try to ensure that there are no objects in your field of view that ruin the picture or distract from the main subject of the picture. Did you accidentally cut out somebody's head, or is there an ugly trash can in the background? A little contemplation before clicking can go a long way.

ALWAYS shoot more pictures than you need. The very small variations in landscape, lighting or picture can make the difference between an okay photo and a great photo! Below are a few techniques that you should consider before taking the picture.

Use Lighting. It Matters the Most

The most important take-away message from this book should be that lighting can be your best friend or your worst

enemy. It is just about as important as your camera itself! Natural sun light is always the best for picture taking, so try to incorporate natural sun light into your scenario. If you're shooting inside, then pull back the curtains and move the subject closer to a window.

If you have artificial lighting, however, then adjust the positions of all the lamps in your favor. Move lamps as close as possible to the subject so there is adequate lighting because artificial lighting is usually very uneven. If there is an overheard source of light, make sure it doesn't overpower the subject. However, if you're trying to go for a creative effect in your picture, then you can adjust the lighting as you please. In that scenario you can even use lighting to create shadows. It all depends on the outcome that you want.

Another interesting way you can use light is by learning how to "shape" with it. Try not to take a picture when the sun is behind you. This just results in flat, boring light on what you are trying to photograph. Instead, it's better to have the source of light either come from the side or from behind the subject, as this makes for a much more interesting photo.

Using Flash

Do not use flash. Just keep away from it. Use it as little as possible. Pictures come out best with other sources of light as the primary source. Try your best not to incorporate flash. Some people consider it a major photography sin! There are some situations when using flash can be beneficial. One such instance is when shooting in bright sunlight. Taking pictures in very bright sunlight can sometimes cast ugly shadows. In this instance,

turning on flash can help fill these shadows out and improve the look of the image.

A flash in bad lighting makes the subject of the picture appear ghost like. Flash can also cause "red-eye." If it is necessary to take a picture in low light, then try to minimize red eye by ensuring that the subject does not look straight into the camera Looking straight into the camera when a flash is used causes the pupils of the eyes to dilate due to the sudden influx of light. Red eye is the result.

Using a Reflector

While mostly used by professional photographers, a reflector makes quite a difference in photographs. A reflector provides a professional look to the pictures by reflecting light onto the subject.

1. Using the Rule of Thirds

This is a very popular tip and also highly important. While visualizing your image, imagine that your shot is being divided by two vertical and two horizontal lines. The purpose is to place your subject either along these lines or at the point where these lines cross. This approach gives a balanced view to whoever is viewing the photo and helps compose an aesthetically pleasing picture. For example, while shooting a landscape, you can place the horizon on either the bottom or the top line. This will

automatically emphasize the sky or the ground respectively.

2. How to Frame

Framing is a technique used to bring attention to something in your picture. Whatever your subject or scene may be, if you shoot the picture through some sort of arch or a window, you frame it. This approach results in pulling the viewer's attention to your point of focus.

Alternately, if you don't want to frame, then try to "fill" your image with your subject. Move in closer so the viewer's eyes move straight to the subject and this creates a more visually stimulating art piece.

These are some of the basic techniques to keep in mind while visualizing the image you wish to create. Next you're given techniques and tips to remember when clicking the shot.

CHAPTER 3

Taking the Winning Photograph

Now that you've thought of the image you want to create and utilized some of the techniques in the previous chapter, you can immortalize the image in a photograph. However, to do this, there are some pointers to keep in mind and you should know how to apply them in your photography.

1. Keep Still to Prevent Blurry Pictures

Many people are taken aback when they see their pictures come out very blurry. This can happen with pictures taken close up OR from a distance. To minimize this, keep a few things in mind. If you are using a big camera with a zooming lens, then you must know how to hold the camera properly.

With one hand, hold the body of the camera and keep your finger on the shutter button. Then, make sure the lens is steady by cupping it with your other hand beneath the lens. Try to keep your elbows as close to your body as possible. If your camera has any inbuilt features that help stabilize images, do NOT be afraid to use them.

Using a Tripod

While carrying around and setting up a tripod can be a hassle, it is beneficial in some shots. If you are trying to take pictures in very low light, or if you want to take many similar shots in a row, then a tripod is suggested. However, it is obviously not advisable when on the move.

When shooting in low light, a tripod is beneficial as you need more light in the camera for a proper photo. However, this means it'll take longer to take a picture (longer exposure and a slow shutter speed). Thus, to prevent blurry photos in this situation, tripods are a lifesaver! Likewise, when you have to shoot something moving very fast at night, you again need something to prevent a blurry photo.

You can create special effects by using a tripod. For example, you can photograph "light trails" at night. Of course this may be quite difficult for a beginner, but a tripod is imperative.

If you don't have a tripod and yet really need to stabilize your images, then here are a few additional tips:

- Get closer to whatever you are trying to shoot and zoom out instead. This approach uses a wider aperture shot and causes less blurring.

- Support the camera against an object or even your own hand. You could also sit down and brace your arms against your knees.

- Press down on the shutter gently and remove the pressure only after the image has finally been taken. Relax and try to take the picture in one quick and smooth move.

- Don't be afraid to use auto focus on your camera. This will improve picture quality. Don't think that you have to do every setting manually; make things easier for yourself. Most of the cameras available today have very advanced focus capabilities. No need to try and fiddle with manual settings in an attempt to be "professional." What matters more is how you compose your photo. Whether or not you compose manually is not important! This sort of auto-focus almost always gets it right.

Get Your Angle Right

Taking a picture of the subject straight on makes for a very boring photograph. One of the best techniques to make a picture interesting is to find an angle that is interesting. Try moving around and see what shot looks best. The mistake that most amateur photographers make is that they take pictures that all look the same. Explore various angles. If you want to make the subject seem smaller, you can take the picture by putting the camera above the subject. If you take it from the below then the subject will look much larger. Crouch or lie down, or take a picture from a higher position. Don't be afraid to get dirty while making art! When shooting pictures of children, try and go to their level to take a better picture.

While shooting pictures of buildings, try taking the photo

from the base of the building and then upwards to the top, trying to "angle up"; your picture will make the building look like a triangle pointing to the sky. While shooting photographs of normal objects, like a pencil then get super close and zoom in on it for more interesting photographs.

Respect the Subject/Object That You Are Shooting

When shooting an object, try not to add too many elements into your picture. It will look like a mess and you will lose the essence of what you were trying to create. Keep it simple. Include just one or two things to catch the audience's eye so your viewer doesn't get confused about what to focus on.

Also, try not to add too many colors into your image. Again, this has the same effect and draws away from the goal of the photograph and comes across as messy!

When shooting portraits, a couple of pointers will make for better photos. First off, always ensure that your subject is at ease. It translates into your photographs. If you're photographing family and friends, then they will generally be more relaxed, but a good joke at the right time is a better method that merely saying "smile" before taking a photo. Soft lighting is best for portraits. Always be conscious of how you frame the people in your shot.

If your subject is someone you don't know very well, then take

time to talk to them; be polite and make eye contact. Your goal should be to have them relax. Also remember if a person is unwilling to be photographed, then respect that wish, too.

Making someone uncomfortable will never produce a good picture!

CHAPTER 4

A Little Art, a Little Magic

To create a beautiful picture here are a few additional pointers to keep in mind. Producing amazing photographs requires more than technique and following rules. It's about incorporating creativity, passion, patience and technique to create brilliant results.

1. Use Colors Wisely

Incorporating the color red creates a warm feeling in your photographs. Blues and greens have a cooling effect. Learn to use colors in a creative manner as colors affect the way the subject looks and colors affect the viewers' response. If you want to add drama or tension to your image, then use many contrasting colors like red, green, yellow and purple. On the other hand, if you want to instill a sense of harmony then try and go for the same type of shade, or contrast color.

Bright sunlight adds intensity to colors and makes them look more saturated, but a cloudy day will make colors feel more harmonious. It's all about using different factors to your advantage. Colors also affect the emotional tone of your pictures. For example, blues and greens have a calming effect; yellow translates into happiness and red signals warning, thus adding drama to your shot.

Black and white photos help create an intimate picture, and since

there is no color, the forms and shapes in the image are what give it depth. Experiment with contrast in your shot to see the effect on the image.

2. Using Lines to Your Advantage

Lines occurring naturally in your photo can create a sense of direction. By lines I mean shadows, light rays, etc. Direction of these lines and their orientation can be very useful in trying to add feeling to your photograph.

Slanting lines suggest some sort of movement or action whereas converging lines in your photograph can denote distance or depth. Lines can also give the illusion of a three dimensional image.

Repetitive elements in your photograph help give rhythm to the picture, which is pleasurable for the viewer.

3. Don't Put The Main Point of Interest in the Center

A major mistake is putting the subject of interest smack in the middle of the photograph. This is not aesthetically appealing. To create a balanced image in the mind of the viewer, keep the subject away from the center but not toward the edge.

4. Follow Your Vision

The most important point to remember is: you don't need to follow anyone to get great pictures—no gurus, teachers or anyone. Try and portray yourself through your photography. Shoot what you feel passionate about; do not copy anyone else's work. When you find something you feel strongly about, explore it. Whatever topic that may be.

There is no good or bad when it comes to photography; what matters is that you capture what excites you. Photograph what you feel curious about. If you want people to find your work interesting, then you must be excited by what you photograph! Do NOT get hung up on technique. Absolutely forget it! Mastering shutter speeds and settings aren't all there is to learn about taking good photographs. That is only part of what is required.

Don't worry if you don't have the latest camera or equipment. Simply pointing an expensive camera at something will not result in a beautiful photo. What matters is making a strong image about what you feel passionate about.

Have Patience

When it comes to photography, you cannot be on a schedule. You need to take a hundred photos before you feel like you've created something truly amazing. It takes inspiration and a little stroke of luck to create a stunning photograph.

So many amazing shots take place after years of

observation. And you will learn only with time and practice what makes for truly amazing photos. This requires perseverance and commitment, and most of all passion. It also means honing up on your skills of observation. Pay attention and you will find many photo opportunities open up in front of you.

Conclusion

Thank you again for purchasing this book! As we move ahead to the conclusion of this helpful piece of writing, we must understand the importance of the commitment this or any other activity demands. What you read above gives clear guidelines of how photography must be perceived, dealt with and practiced. You will only master the skill if you put forth effort to learn photography.

The best photographs are the ones that don't require long hours of editing and fixing. You shouldn't have to sit in front of the computer for hours correcting the mistakes on camera. Nor should you take photographs with the mindset that wherever you mess up, you can easily edit the mistakes. This inhibits learning. One should learn how to take excellent photographs without turning to software programs for massive editing. Like any other skill, photography is also an art that can always be improved upon. Even the most experienced photographers never stop.

Once you have started off with the basics, get out every day and take photographs. Visit zoos, parks and gardens and experiment with pictures of the vibrant-colored animal and plant life. Take as many photos as you can! The more you shoot, the better you will get. Whatever gets you excited or sad, or even angry—shoot it all. The best photographs are the ones that communicate the photographer's mindset through the image.

Try reading as much as you can about photography, and study the pictures thinking about what the photographer was trying to communicate. This gives you more ideas to incorporate into your own work. Also don't keep buying pricey camera equipment; instead, buy books on photography. It is the photographer that creates the magic, not the camera!

Join a photography group or community where you can learn from great photographers and acquire new techniques! Last but not the least, have patience. Your photographs will get better with every photo you take. In fact, don't be afraid to break rules when it comes to photography; have fun with it and experiment. The more mistakes you make, the more you'll learn. Now go out and shoot!

Finally, if you enjoyed this book, please take the time to share your thoughts and post a review on Amazon. It would be greatly appreciated!

Thank you and good luck!

www.ingramcontent.com/pod-product-compliance
Lightning Source LLC
Chambersburg PA
CBHW021546200526
45163CB00015B/2441